Permissions for Healing

21 Days of Paintings
created by
Helen Wagner

21 Days of Poems
written by
Joanne McNamara

~ Inspired by each other ~

DEER RUN
PRESS

Library of Congress Control Number: 2021944691

ISBN: 978-1-937869-13-7

First Printing, 2021

Additional copies of this book may be obtained online, Deer Run Press, the authors, or your local bookstore.

The authors may be emailed at handjhealing@gmail.com

Published by
Deer Run Press
8 Cushing Road
Cushing, ME 04563

Contents

Introduction 5

Day 1 Permission to Begin 6

Day 2 Permission to Visualize 8

Day 3 Permission to Trust 10

Day 4 Permission to Heal 12

Day 5 Permission to Play 14

Day 6 Permission to Express 16

Day 7 Permission to Dream 18

Day 8 Permission to Hug 20

Day 9 Permission to Explore 22

Day 10 Permission to Feel 24

Day 11 Permission to Receive 26

Day 12 Permission to Cry 28

Day 13 Permission to Inspire 30

Day 14 Permission to Forgive 32

Day 15 Permission to Believe 34

Day 16 Permission to Be 36

Day 17 Permission to Ask 38

Day 18 Permission to Change 40

Day 19 Permission to Write 42

Day 20 Permission to Share Reiki 44

Day 21 Permission to Complete 46

Free space Permission to_____ 48-51

Acknowledgements 52

About the Authors 53

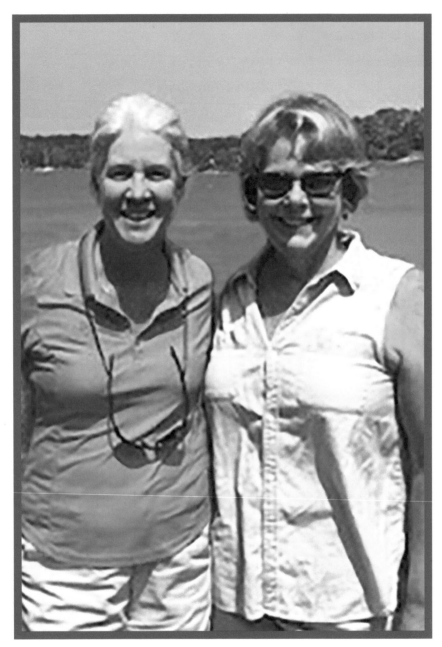

Helen & Joanne

Introduction

Many things happen in our lives to make us forget that we have the right to experience feelings, thoughts, creativity, etc. We have jobs, families, friends, pets, responsibilities, habits (good and bad) that consume our time and being. It is sometimes challenging to remember that we must honor ourselves and grant ourselves permission to be, feel, and express our individuality. This helps give us the ability to heal ourselves and others. Never has there been a time as important as now to experience self-care and love.

This book, *Permissions for Healing*, was born of the authors' attendance at a Reiki Master class at the Kripalu Center for Yoga & Health nestled in the Berkshire Mountains in western Massachusetts. Reiki Master Libby Barnett, MSW, provided "permission slips" to her students to help begin a process of self-discovery. Through Helen Wagner's interpretive paintings of the permissions, Joanne McNamara was inspired to write poetry and, at times, Helen would create her art based on Joanne's poems. You will see hands in each of the paintings, which is from where the universal energy of Reiki flows. The paintings and poems were exhibited in Cushing, Maine during the summer of 2018. From that exhibit, there was a request for a book encompassing the art and poetry that might be useful to those struggling in life.

We hope you enjoy the experience of moving through this book. Please give yourself the permission to take time to think about and create your own permission slips on the pages at the end of the book. Who knows? That exercise might help enhance your life in some way....

Much love,
Helen & Joanne
handjhealing@gmail.com

Permission to Begin

"I realize, life will never be the same again on this side of my initiation," as Danna Faulds writes. I have permission to begin.

Begin what?

The words that change the paper from white to wonderful with the stroke of a pen.

Or is it a brush that fills the space with the color of hands that work to comfort around the land?

Comfort what?

Pain, she said. Invisibility, he said.

Discomfort, stress, fear, anxiety, loneliness, addiction, dis-ease, and anger.

How?

The hands, and those who own them, will help transform the world to prioritize peace, love, kindness, relaxation, imagination, creativity, caring, and compassion. One hand and heart at a time...

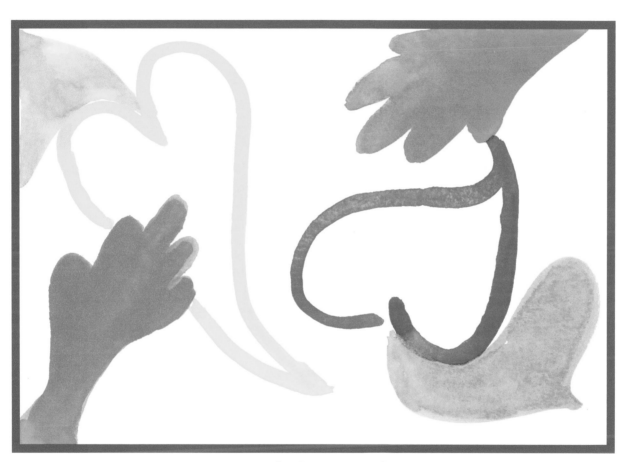

Permission to Begin

Permission to Visualize

The crystal image in my mind
Makes clear those needs and wants of time
Where picket-fenced-in gardens grow
Where kids and pups dance to and fro.
To college, careers, with rhythmic waves
Excitement, a move to a new place -

It is now time to see within
The layered heart is whole, as I have been given
The gift of touch, as if my hands were the key
To unlock whatever needs to be released from the sea.

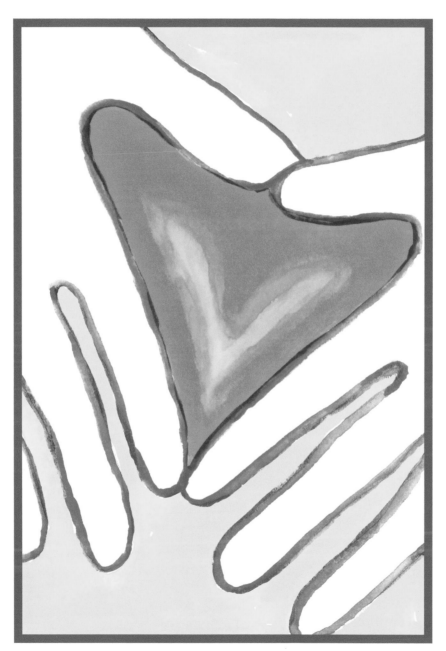

Permission to Visualize

Permission to Trust

Pinky promises and forever friends
Initiate a trust that we hope will never end.
We know the grass will grow and the moon will shine
Can we take the leap to know that everything is fine?
The world is changing one moment at a time.
Equanimity is a goal of mine.
The universe provides opportunities each day
To be open to trust what's coming our way.

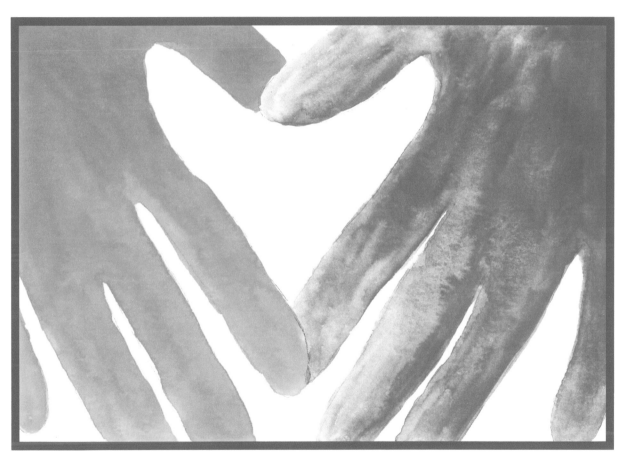

Permission to Trust

Permission to Heal

The warmth is radiating through her back,
Finding the aches from the heavy pack
Of thoughts, stories and yarns spinning in her spine
That burden the spirit, that occupy the mind.
Healing energy; collaborating for a cure
She says, don't stop; the energy is pure
And potent, going right to the source
Of the trauma that has brought her to this wild course.
It lessens the intensity of the parade
Of those continuous mindscapes that support the charade.
May this be the stop of the addiction to thoughts.
The healing through hands saves lives of the distraught.

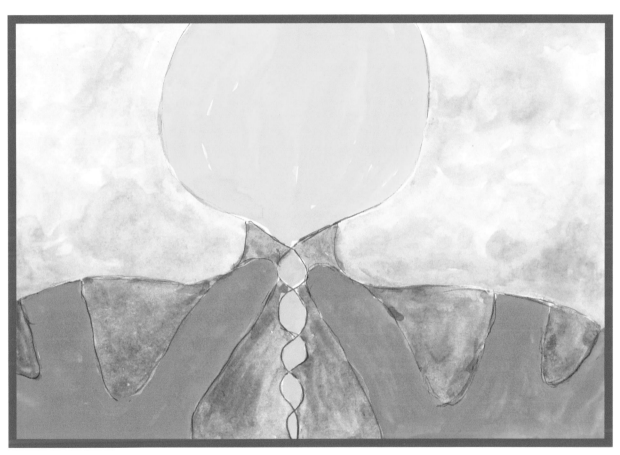

Permission to Heal

Permission to Play

"Come play with me," a voice said to thee.

"Let's have some fun while in the sun,
Like swing on a tire and jump in the lake.
Searching for turtles and tadpoles, not snakes!
Shall we sing and dance to sweet songs in the moonlight?
Or go hide and then seek in the dark of the night?
Or play 'Red Rover, Red Rover Send My Best Friend Right Over'
Or lie watching the clouds in a field of pink clover?
Let's build and fly a colorful kite!
Don't forget Scrabble, Gin Rummy, or the Game of Life.
Tennis or pickle ball can get our hearts racing
Or skiing down mountains and fun times ice skating."

The options are endless when we set ourselves free
To let playtime take over to help make us see
This fun is important to balance the soul
And ensure that life's pressures do not take a hold....

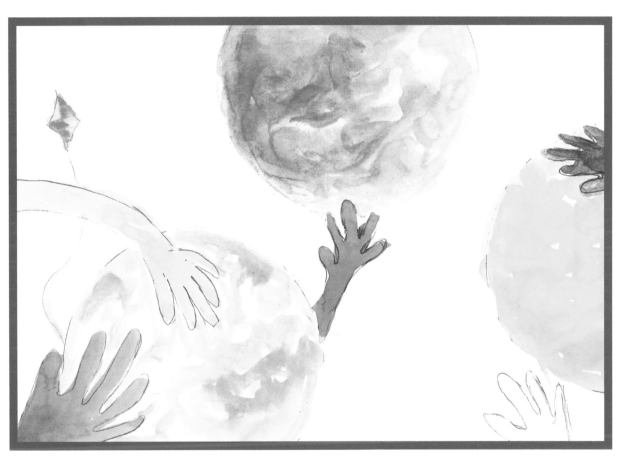

Permission to Play

Permission to Express

The heart is open to give and share love
Its beats are like the rhythm of a dove's
Mourning call in the background woods
That brings the soulful sound of nature saying "Good".
Now is the time to express yourself with words and art and song,
It is the transformation of the heart that makes you feel you belong.

OR NOT?

Dancing to your own heart's beat
Brings the joy of freedom to create,
Though not all agree, and conflict may berate.
The only person you must please is you!!!
The universe then hums and happiness will rule.

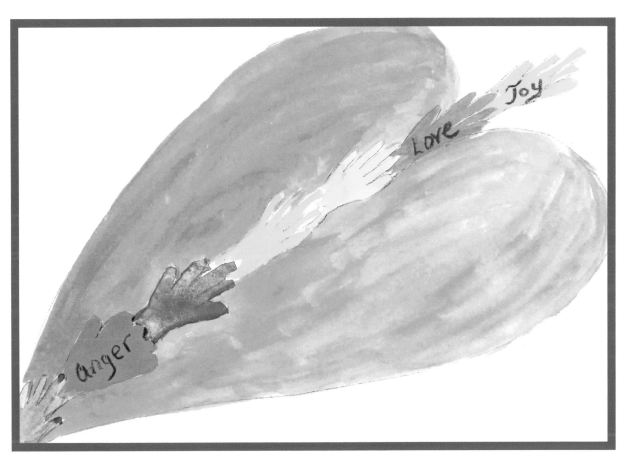

Permission to Express

Permission to Dream 1

Fairy tale characters come into my head
As my body lies sleeping in my bed
Having tea with the Queen and toast with the cat
Swimming in the ocean with seals that are fat
Up to the heavens from star to star
Down to Australia where kangaroos are
Talking to reindeer vacationing in the south
All while I lie sleeping in my little house.

Permission to Dream 2

The world will be a different place
where love will reign and peace is the state
of all minds in the universe
the presidents and politicians that serve
our country, as well as rulers beyond
they'll make amends across the pond(s)
the stars will smile and say adieu
to the hate, discord, and sadness.

Hands will join to help end all this crazy madness
of losing children in the schools
and so much hunger in the world.

Kindness will become the universal message.

Permission to Dream

Permission to Hug

Warmth of arms surrounding me,
Breathing in love, protection, empathy,
Breathing out fear, sadness, insanity.

My arms are also surrounding you,
Giving hope, recognition, the ability to undo,
Any actions, thoughts or words that may
Not harmonize easily with the way
You meant for the world to feel your pain.

Our arms send strength to help us gain
The confidence to do what's right
For each of us, with that hug so tight.

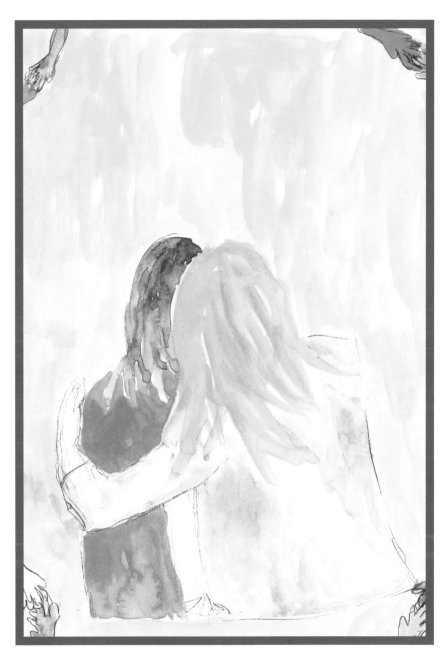

Permission to Hug

Permission to Explore

Hands in poses on and off the floor
Give us reason to explore
What the body can define
As exercise for the mind.

Yoga brings words of Namaste and Meditate,
This finds us being in that state
Of here and now,
But let us not worry about the how.

Intention is fulfilled throughout the day,
As we further explore how the body can stay
Grounded on the mat, on the floor, on the earth.

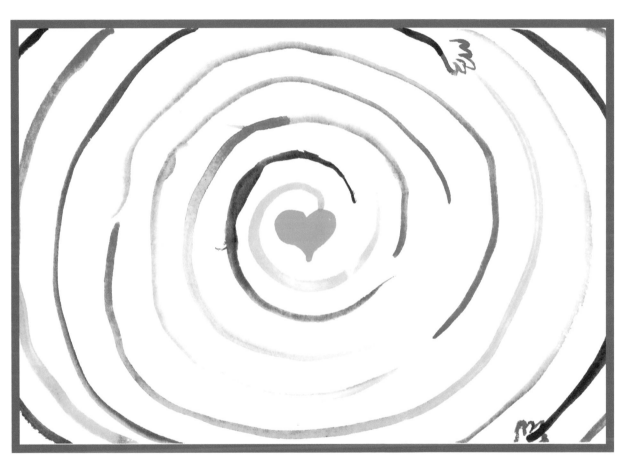

Permission to Explore

Permission to Feel

The Mind

Inspecting the feelings of the mind,
We honor each one as they find
The pushed buttons, the sorrowful tears,
The beautiful sight of little lambs' ears
Each feeling elicits a reaction -
Positive or negative; both give us traction
To move forward with the process of healing...

The Body

Warm, hot, weak, strong, tired, and cold,
These feelings touch our skin and bones.
Imagine if we couldn't feel
These sensations that make life real,
To move the body to get a blanket, rest, or bother
To give to and receive help from others.

The Spirit

Love is what we feel in our hearts.
It welcomes joy and gladness with the start
Of a sunrise across the bay,
Then the sound of birds as they seemingly say
Come play with me, let's chase the rainbow
Let's soar through the clouds and then dive low
To the bubbling brook as the sun sets slow.
The feeling of peace is in the air,
Then we close our eyes without a care.

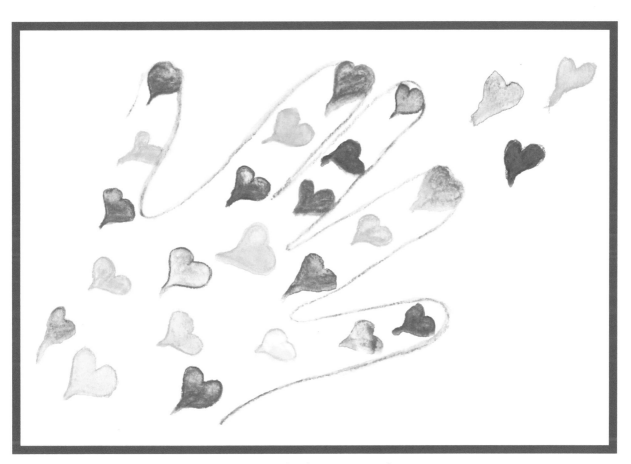

Permission to Feel

Permission to Receive

Many of us want only to give
but it is so important that we live
a balanced life of give and take
and learn that receiving is what makes
the world go `round and `round...

So, when a friend comes bearing gifts
or offers you a compliment
you must be prepared to be content
and utter a simple thank you.
The other part of receiving is lots of gratitude!

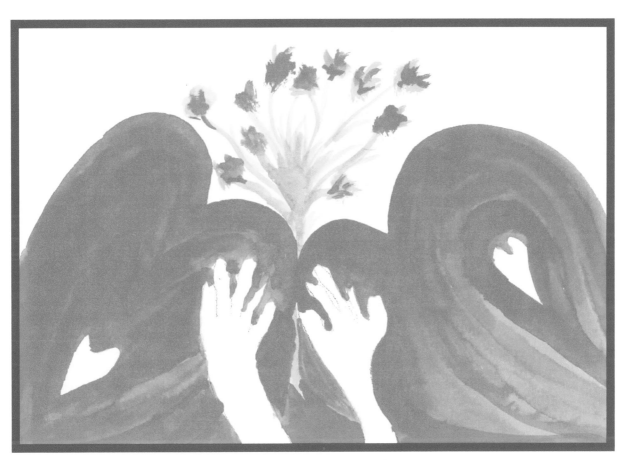

Permission to Receive

Permission to Cry

Those tears who have been hidden for years and years,
Need to reveal the depth of my fears
Of not being good enough. Of failure. Of speaking my truth.
These have followed me since my youth.
When fears arise, tears may flow until the well runs dry.
Now is the time to love myself and give me permission to cry.
Those fears will be healed with the flow of the tears
For joy. For happiness. For honesty, my dear.
The tears will infuse the soul
To make you and others whole.
With the help of the energy that comes through the hands,
They will comfort and protect as you strongly stand.
Those tears will create rivers of hope throughout the world,
And, finally, your strength and power will be unfurled
Because of having permission to cry.

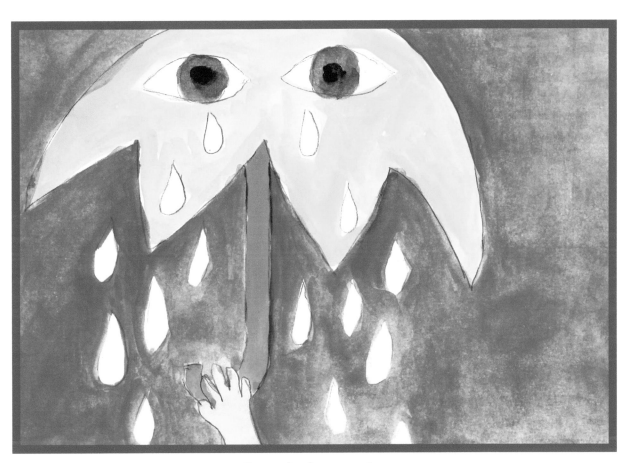

Permission to Cry

Permission to Inspire

The motivation of the mind
Makes me take my pen and find
A space to sit with thought and wait
For inspiration to create
Words that rhyme.

They don't just rhyme but have meaning, too
That will inspire and motivate you
To move your body, get up and dance,
Paint a canvas, or grow some plants!

Setting the table with pretty dishes
May inspire a meal that is delicious.
Sewing a beautiful quilt of color
Could lead to helping one another
To see the beauty of the day.

Words that offer hope, transform and end hate,
May heal and wash those pesky worries away.

Please relax and be led
By those ideas that stray into your head;
They may clarify your purpose and inspire.

Permission to Inspire

Permission to Forgive

Who do I need to forgive?
The next-door neighbor or the kids?
For what, I ask, could they have done?
To make me mad, upset, or glum?
Is it my husband, brother, or dog?
I don't think so, as I clear the fog,
There is no harm that has been done.

So, who is left to blame? Just me!
I need to forgive me for my shame
About worries of my body image
And not doing enough for those I love.
Forgive and remember not just the bad
Think of the times I helped the sad.
Those who were grieving, sick, and sore
Donated clothing and food to the poor.
Made flower bouquets at the home,
To brighten the days of those not on their own.

So, get out of your mind, forgive yourself and feel
You are free to help others forgive and heal.

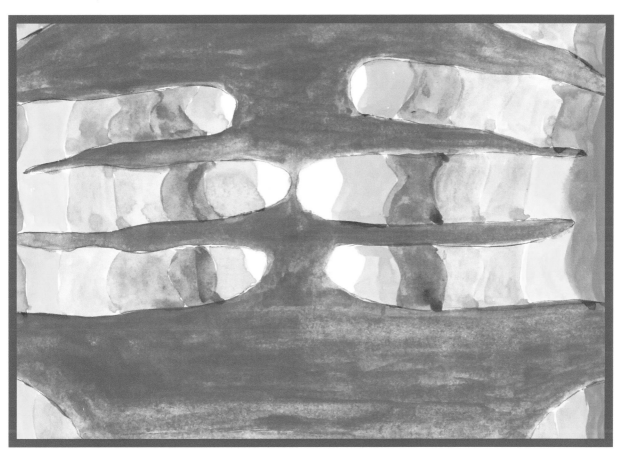

Permission to Forgive

Permission to Believe

The angels are looking down on me
As I sit under the great elm tree.
Familiar faces I see above;
There's my Mom, the mourning dove,
Showering Dad, the daisy, with lots of love.
And Grammie, the cardinal, sings her bright red song;
She always loved the angels and the world beyond.
Don't forget sweet Maggie, she came back as a Rose,
Loving, as always, with that cold nose.
I believe they are up there guiding when they can
To help me serve my purpose of healing with my hands.

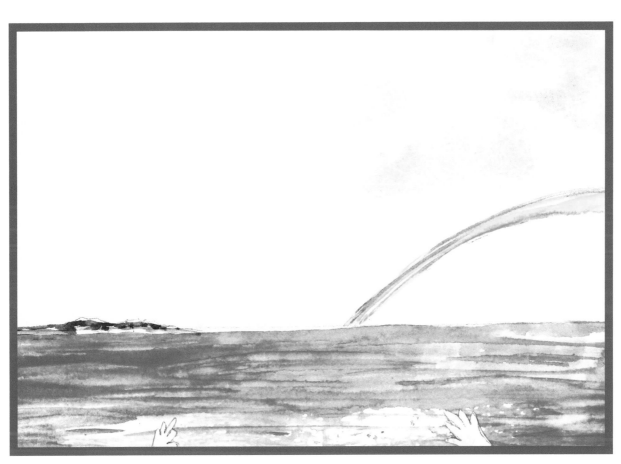

Permission to Believe

Permission to Be

Be What? A Poet, A healer, A mother, A daughter,
A confidant, A friend.
The list goes on; it does not end.
Some days, I'm a dreamer and others, a cleaner
(though my husband will say that he's not a believer
that I can clean as well as he!).
But onto other things that I can be:
Kind, supportive, and thoughtful to help others see
That they have the wherewithal and the key
To be whatever they want to be.
A dancer, A painter, A candlestick maker,
An astronaut, An oceanographer or An equestrian.
So many hopes can become a profession!
There is also the concept of just "to be"
To sit and contemplate the sand and the sea.
Or wonder where the stars may fall
and whether your wish will come true at all.
But the bottom line is to be one's self –
As there is no one else, like you.

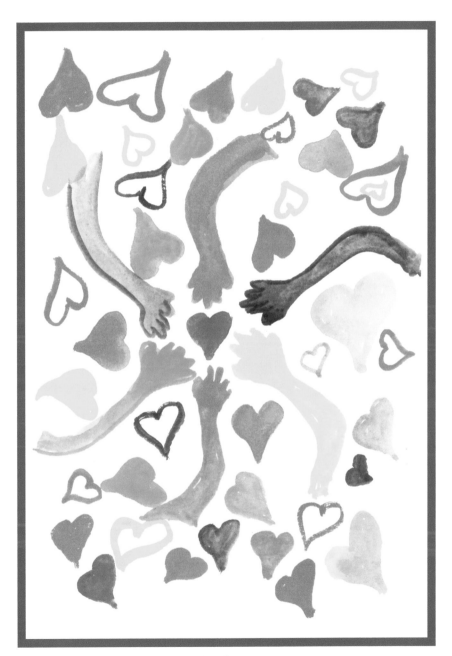

Permission to Be

Permission to Ask

Why is it so difficult for me to ask
When I need help with a task?

Is it independence or control
That prevents me from being bold
Enough to request a little assistance
Every now and then?

I now have permission to ask,
Not just for help but also why, how, and when.
Questioning thoughts and actions while trying to be Zen!

It's okay to be strong but there may be times
That requests and questions are simply fine.
So ask away to help gain clarity
And relieve the stress of perceived responsibility.

Surrender to yourself and ask, as you are certainly worthy....

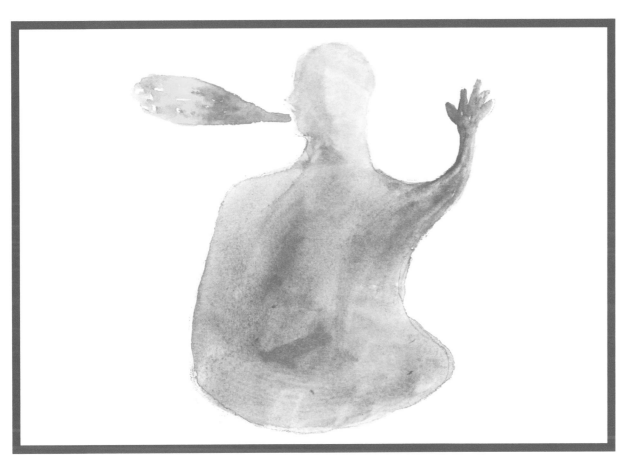

Permission to Ask

Permission to Change

Impermanence is a given....
New England seasons are an example that we are living.
They move us from our comfort zone and make us grow,
Like the tender crops of crocus, that pop out from the snow.
They fade as the sun gets warmer and other flowers bloom,
Showing off their summer colors that will be gone all too soon.
We rejoice for the harvest, because we know it brings us food, but -
The cold is right behind it, which puts a damper on our mood.
We hibernate and create to help us change with the flow,
We anticipate the days `til spring arrives as we transform and grow.

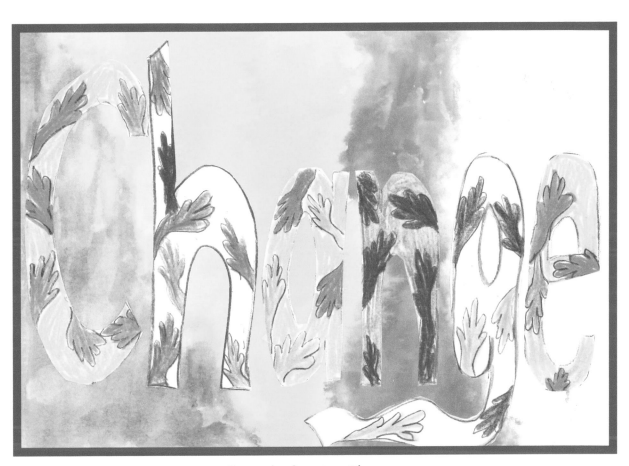

Permission to Change

Permission to Write

One of the greatest gifts is the permission to write.
The words flow faster than I can type.
All worries of spelling and grammar are gone.
So forgive me if the cadence is wrong
Or the personification isn't quite right.

The joy that I feel while writing this spiel makes me feel so light.
Even when the spark of sadness arrives, indicating the topic is dark,
The exercise of writing it down has absolutely left its mark
On my soul. The words have a mind of their own.
They flow from my hands and work to make me whole.

Permission to Write

Permission to Share Reiki

This energy that comes through the hands
Came to us from Japan.
Bringing relaxation to the body, we find
It helps beings heal and quiets the mind.
Connecting to our higher selves,
The energy flow can make us well.
Hospitals now have this practice
To help patients be calm and relax.
Reiki works on animals, too -
Hands-on healing can happen at the zoo!
Sharing Reiki is a gift
That may well help the world to shift
To a kinder, more compassionate place;
One hopes, at least, that will be the case.
So please sit down and let us share
This relaxing practice that can ease your cares,
Abide for a moment as you feel the heat
Our hands give out and our energies meet.

Permission to Share Reiki

Permission to Complete

That sense of an ending, elation, it is finally done!
Completing the project that has been so much fun.
Excited to think what our work will become.

Hoping to help those in need of a lift
To let each know, that they are a gift
To the world as we know it, just as they are,
Unique and different as each shining star.

That bright blue banner with hands in a circle,
Reminds us that energy touches those with hurdles.
Real or perceived those hurdles will crumble,
As one surrenders to healing hands of the humble.

We suggest that you find a nice corner or nook
To sit and write *your* permissions in this book.
Maybe it's to start or to stop, or to love or to hope,
Possibilities are limitless, when your broaden your scope!

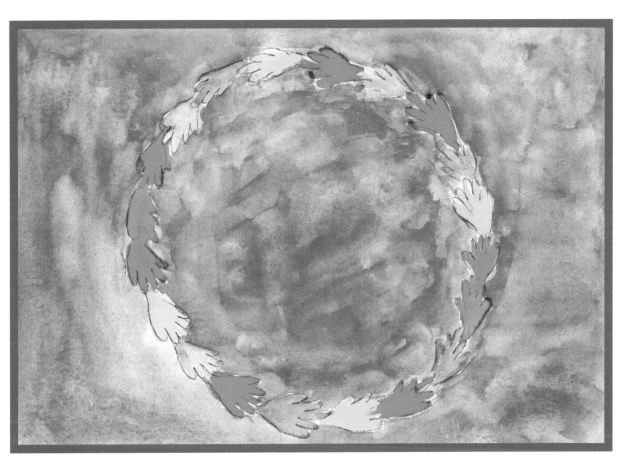

Permission to Complete

Permission to _____

Permission to _____

Acknowledgements

We are forever thankful to the following souls for help and support along the way. Libby Barnett, MSW, for her beautiful Reiki teachings and sharing the permission slips, for without her, this project would not have been initiated. The Sacred Tides family for expanding our awareness and helping us to believe that this book would become a reality. Cindy Simon, for providing coaching and edits that enhanced the writing flow. Kate Hoyt, who really zoned in on the rhythm of the words and provided thoughtful suggestions for cadence and clarity. Danna Faulds, who gave encouragement and permission to use the first line of Permission to Begin from her poem "Initiation" from her book *From Root to Bloom: Yoga Poems and Other Writings*.

The guiding light for Joanne has been the memory of her grandmother, Madeline Power Peach, who loved to write poems. Joanne is grateful for her strong and adventurous spirit that allowed Madeline to try all kinds of new things, well into her nineties. She sought out healing alternatives to help her feel better such as acupuncture and chiropractic services, during a time when they were not accepted practices.

From birth, Helen's guiding lights have been her loving parents, husband, Whit, and their three amazing children who have always encouraged her to follow her heart.

Thank you to the many friends and family who have viewed and read our work and provided positive feedback to help keep this book dream alive.

About the Authors

Helen Wagner

Helen has always loved to draw, doodle, paint, decoupage, and create: she loves color! For 15 years she was an elementary school teacher and always incorporated art in her curriculum. Once she retired, she became a volunteer, teaching art to women in a prison. Over the next 10 years of working with these women in prison, she became known as "The Card Lady." They loved to make cards that they could use to communicate with family and friends. Helen also had a decoupage business with a friend for 10 years. They designed everything from lamps, waste baskets and Kleenex boxes, to trays and floor cloths. For many years Helen and her daughter had a fabric necklace business. They found fabrics and beads from around the world and combined them to make their unique necklaces. For the past several years Helen has been learning Reiki. She became a Reiki Master and was inspired to incorporate Reiki into her artwork. Helen is a graduate of the National College of Education in Evanston, Illinois, and currently spends her time between South Carolina and Maine.

Joanne McNamara

Joanne has been writing poetry since she was a child, mostly for birthday and holiday celebrations. In 2011 she took some time off from her 30+ year career in banking and became a Reiki practitioner. She fell in love with the practice of helping people relax and feel better. Joanne always enjoyed working with children and seniors. Her volunteer activities included making arts and crafts with children during special events while her two boys were in elementary school. She chaired the Garden Therapy program sponsored by a local Garden Club for several years where volunteers visited assisted living facilities and helped residents make flower arrangements. She was also a Hospice volunteer for Steward Healthcare. She has a "passion for trash" and always carries an extra bag to help keep the roads clean while she's walking her dog Rosie. Joanne is a graduate of Colby-Sawyer College and Boston University and currently spends her time between Wells and Cushing, Maine.

CPSIA information can be obtained
at www.ICGtesting.com
Printed in the USA
BVHW091441141221
624009BV00002B/29